MICHELE CASTAGNETTI
/ SOME WORKS

MICHELE
CASTAGNETTI
ALLOWS
PLENTY
OF
WIT
INTO
HIS
ELEGANT
AND
OFF-
PUTTING
WORK.
AT
THE
SAME
TIME
HE
MAKES
PICTORIAL
AND
PRODUCTION
DECISIONS
THAT
DEFY
AND
YET
SPEAK
IN
THE
LANGUAGE
OF
HIGH
ART,
AND
THAT
APE
POPULAR
VISUAL
FORMS
WITHOUT
DISAPPEARING
INTO
THEM.
PETER FRANK

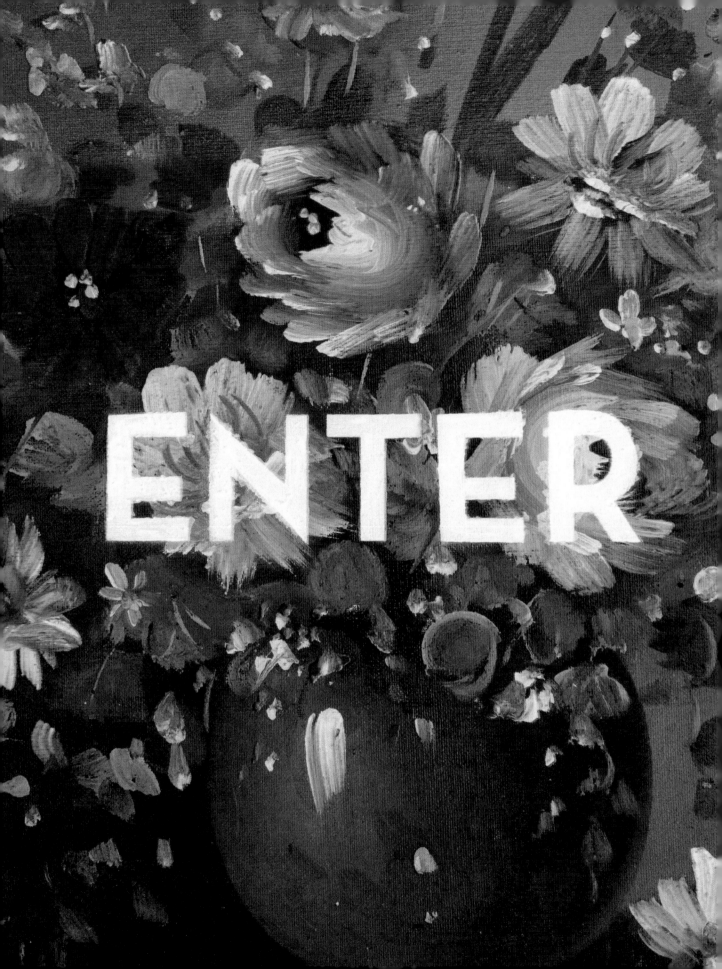

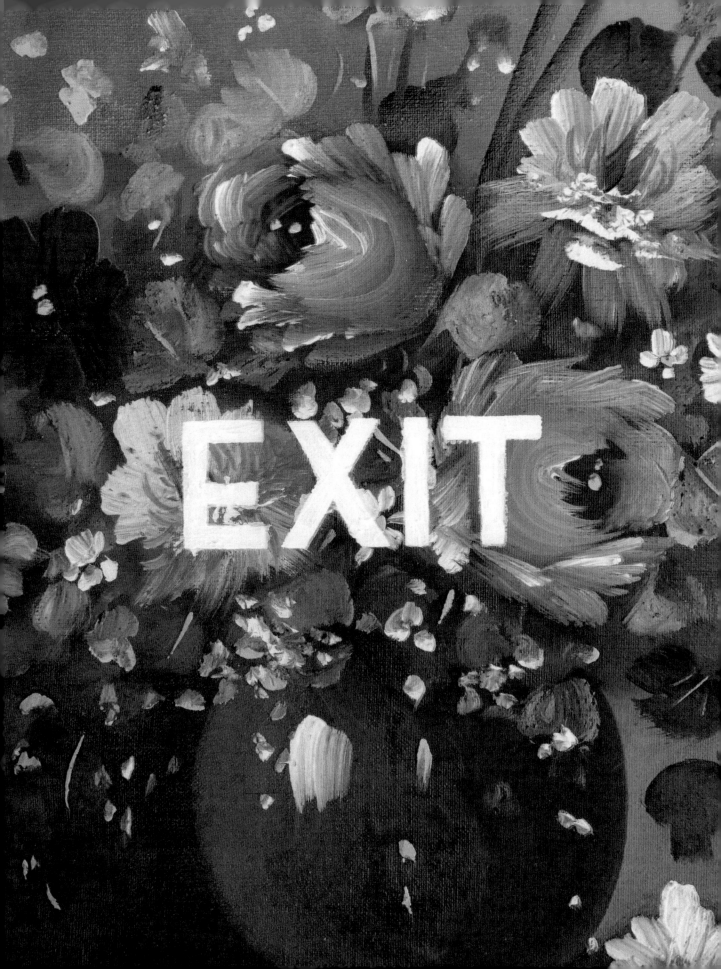

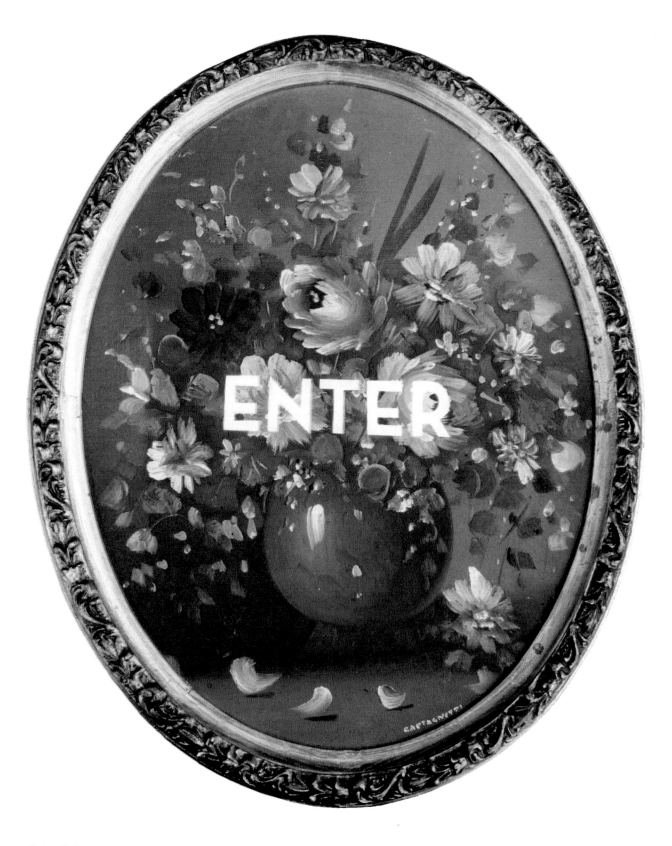

Enter. Exit.
Acrylic on vintage oil canvas
18X22 inches · each, framed (45X56 cm)
Los Angeles, 2020

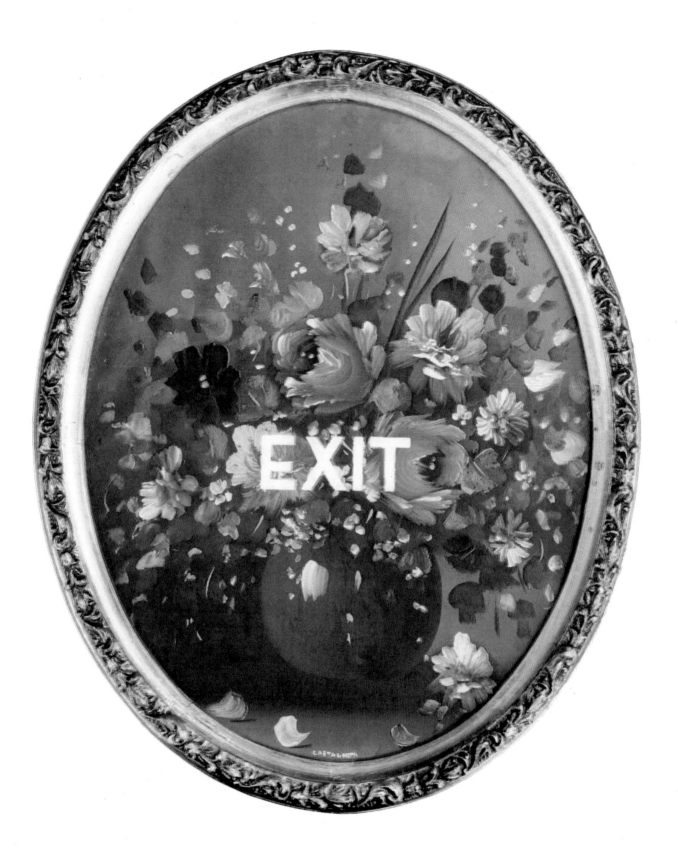

Bohemian Capitalist
Acrylic on antique oil canvas
22X28 inches (45.5X63 cm)
Los Angeles, 2021

BOHEMIAN
CAPITALIST

Don't Imitate, Decapitate
Acrylic on antique oil canvas
18X25 inches (45.5X63 cm)
Los Angeles, 2020

ED

JRU,

T BAD?

I Fucked the Guru
Acrylic on vintage oil canvas
18X24 inches (45.5X61 cm)
Los Angeles, 2018

ALL I NEE
IS A GOC
CONNEC

ED
OD WIFI
CTION.

WIFI
Acrylic on vintage oil canvas
21X27 inches (53X68.5 cm)
Los Angeles, 2019

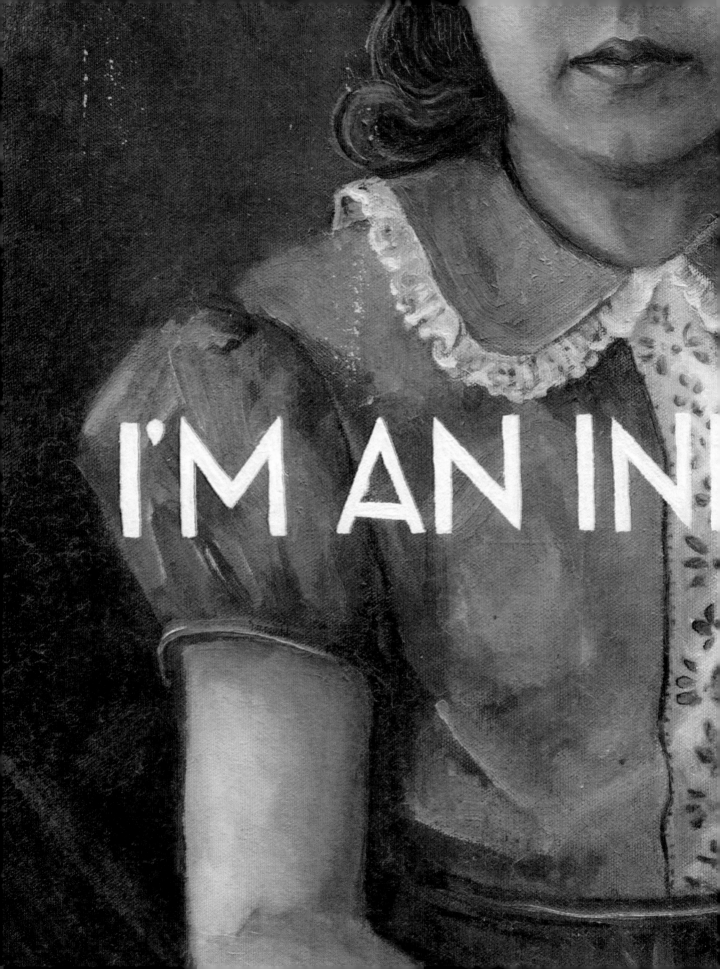

FLUENCER.

The Influencer
Acrylic on vintage oil canvas
21X27 inches (53X68.5 cm)
Los Angeles, 2019

I'M AN INFLUENCER.

CASTAGNETTI
2019

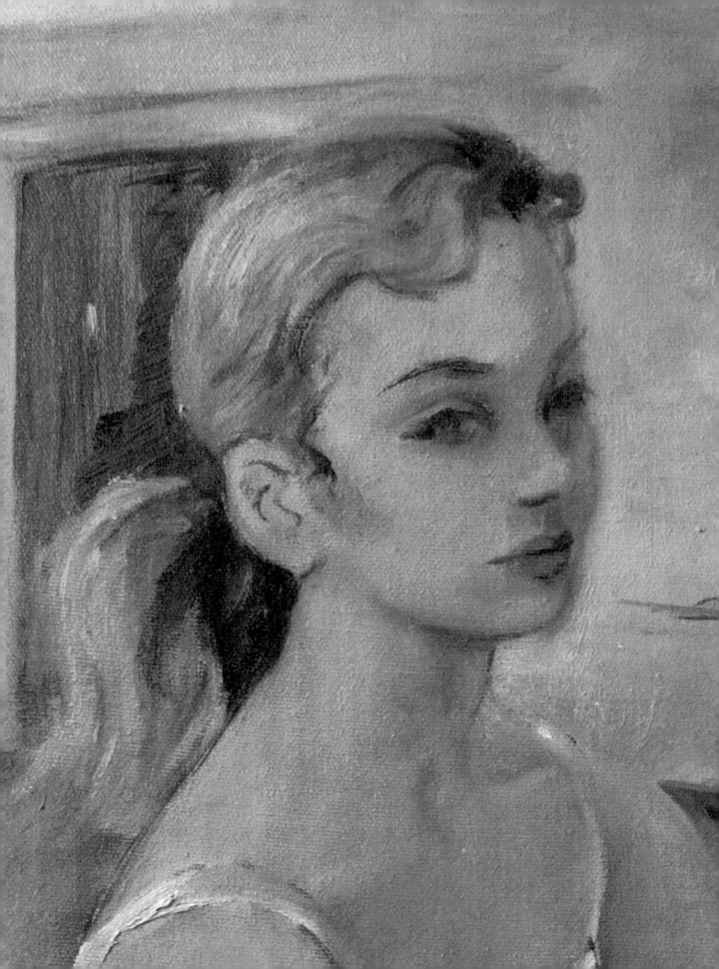

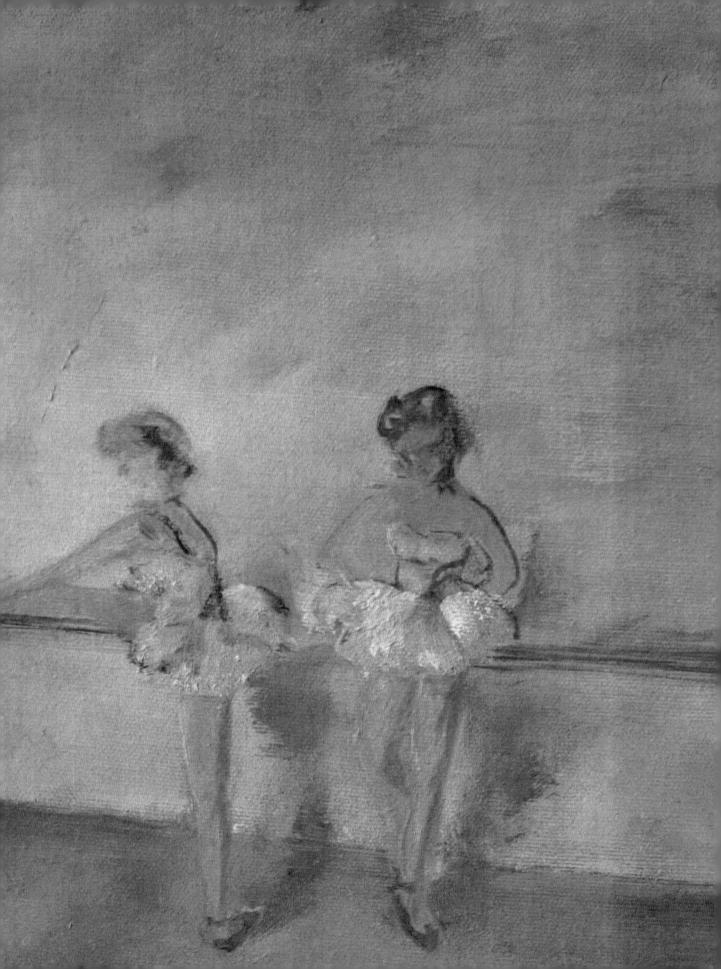

Fuck Your Brand
Acrylic on vintage oil canvas
20X24 inches (51X61 cm)
Los Angeles, 2019

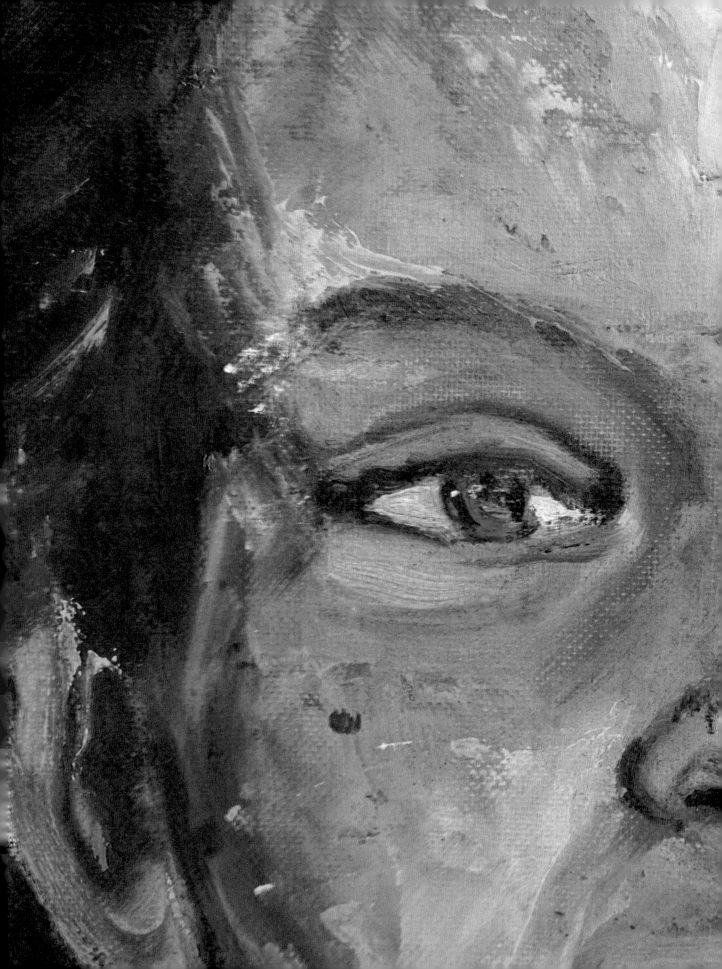

My Playlist Is Better Than Yours
Acrylic on vintage illustation board
14X18 inches (35X45 cm)
Los Angeles, 2019

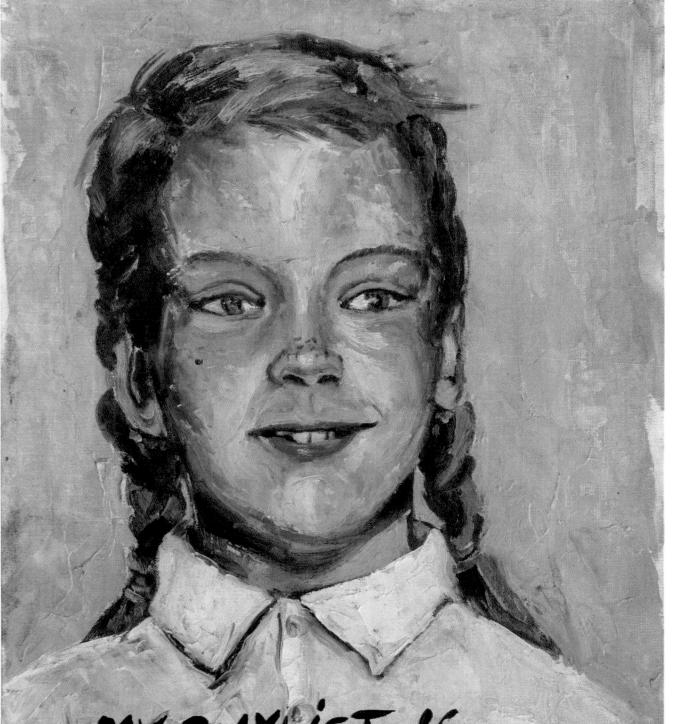

MY PLAYLIST IS BETTER THAN YOURS.

CASTAGNETTI M.

The Jedi
Acrylic on vintage oil canvas
44X24 inches (111X61 cm) framed
Los Angeles, 2019

BITCH,
DON'T YOU KNOW
I'M A JEDI.

EPISODE X

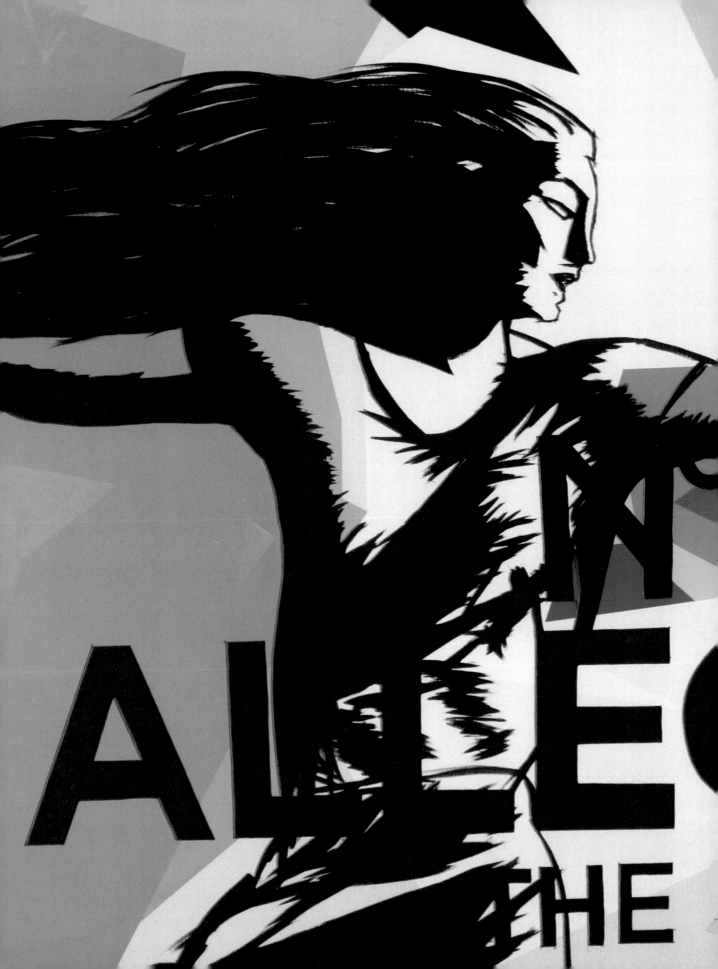

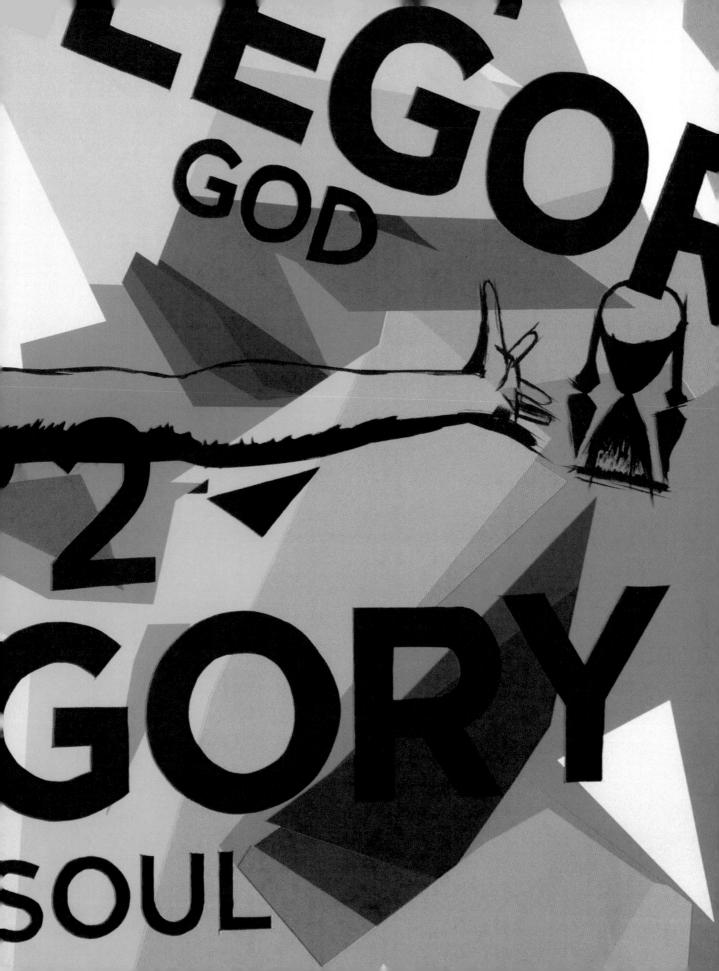

Allegory
Acrylic and Ink on canvas
68X52 inches (173X132 cm)
Los Angeles, 2018

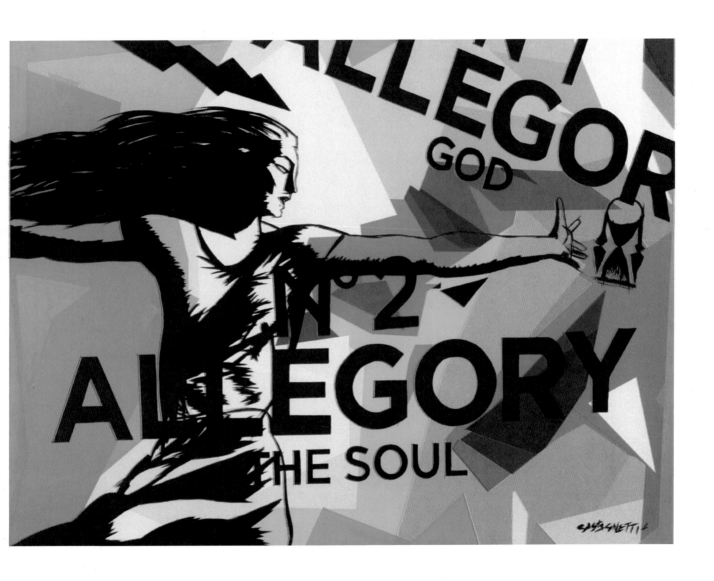

Just Run Bitches
Acrylic on canvas
48X60 inches (122X152 cm)
Los Angeles, 2019

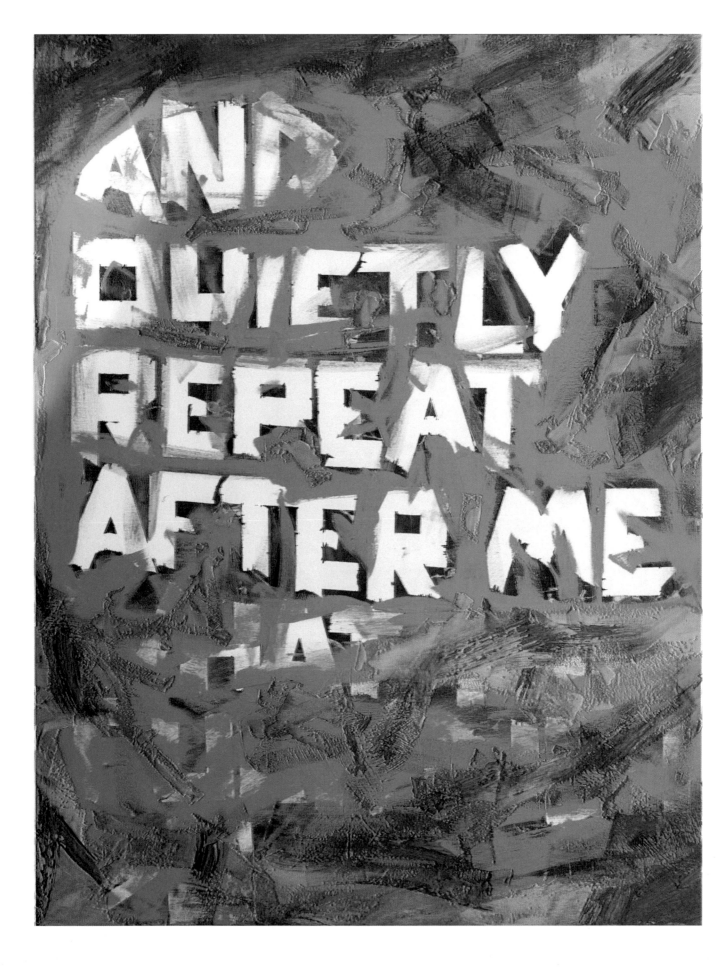

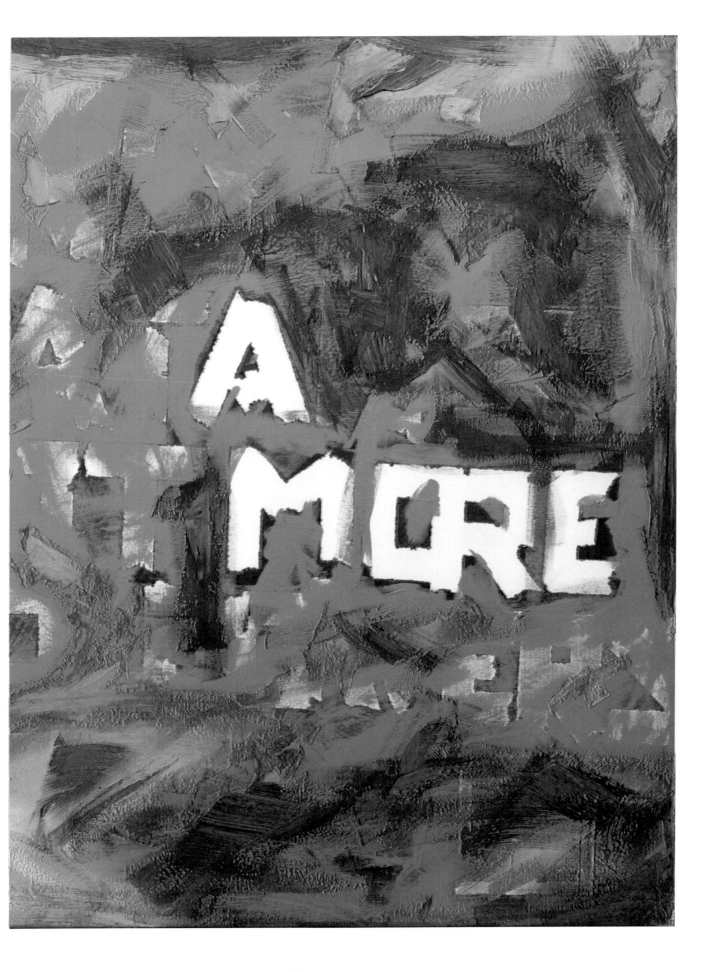

Be The Change
Acrylic on canvas
96X60 inches (244X152 cm) diptych
Los Angeles, 2019

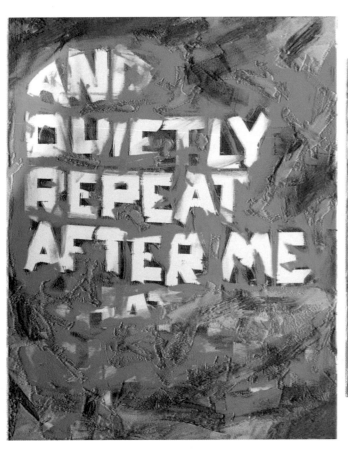

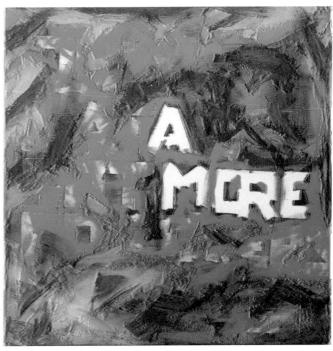

OMG
I CHANGE
3 TIMES
A DAY.

And Quietly Repeat After Me... Amore
Oil on acrylic canvas
96X60 inches (244X152 cm) diptych
Los Angeles, 2020

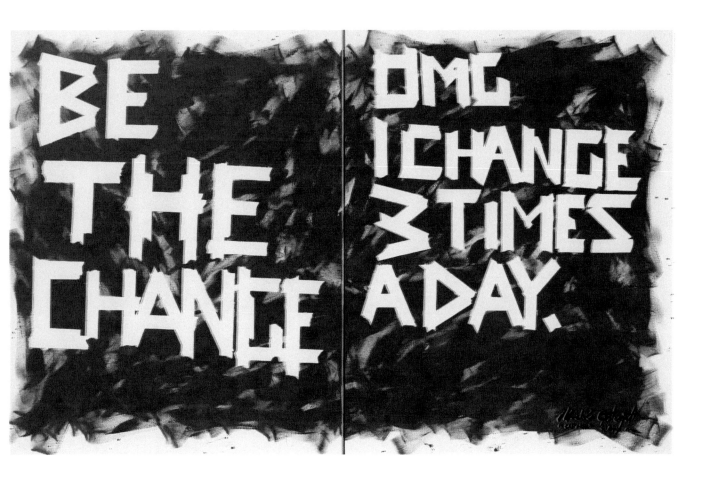

Patience We Are Working On Your Future
Acrylic on canvas
48X60 inches (122X152 cm)
Los Angeles, 2019

PATIENCE.
WE ARE WORKING
ON YOUR FUTURE.

You Are Here
Acrylic on canvas
48X60 inches (122X152 cm)
Los Angeles, 2019

YOU ARE HERE

Electro vs Rock
Acrylic on canvas
48X60 inches (122X152 cm)
Los Angeles, 2019

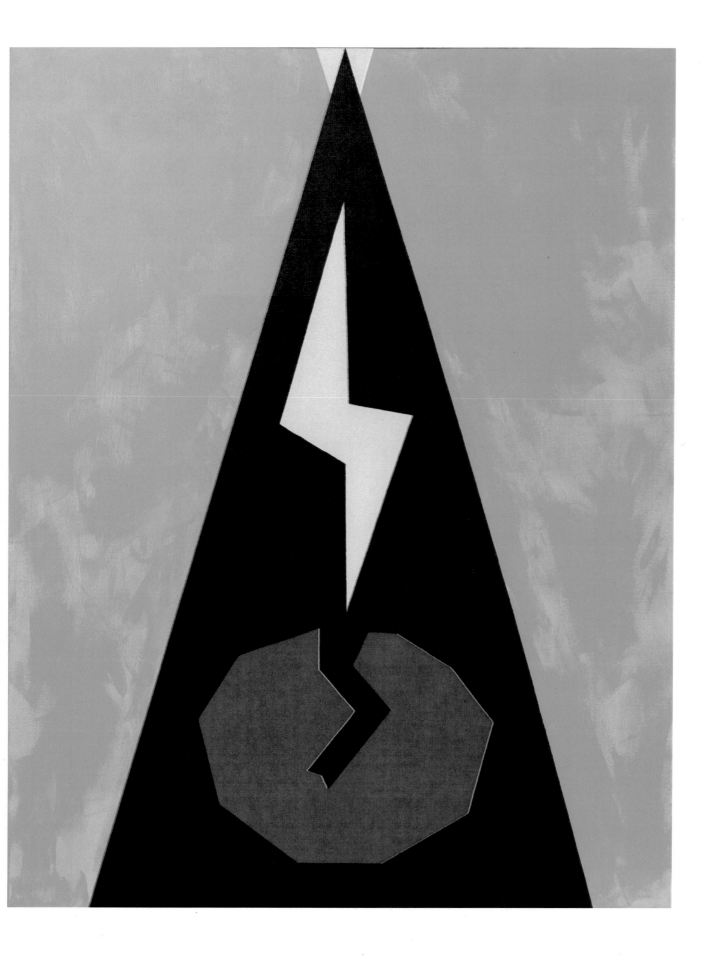

In A Short Time, This Will Be A Long Time Ago
Acrylic on canvas
48X48 inches (122X122 cm)
Los Angeles, 2020

IN A SHORT TIME THIS WILL BE A LONG TIME AGO.

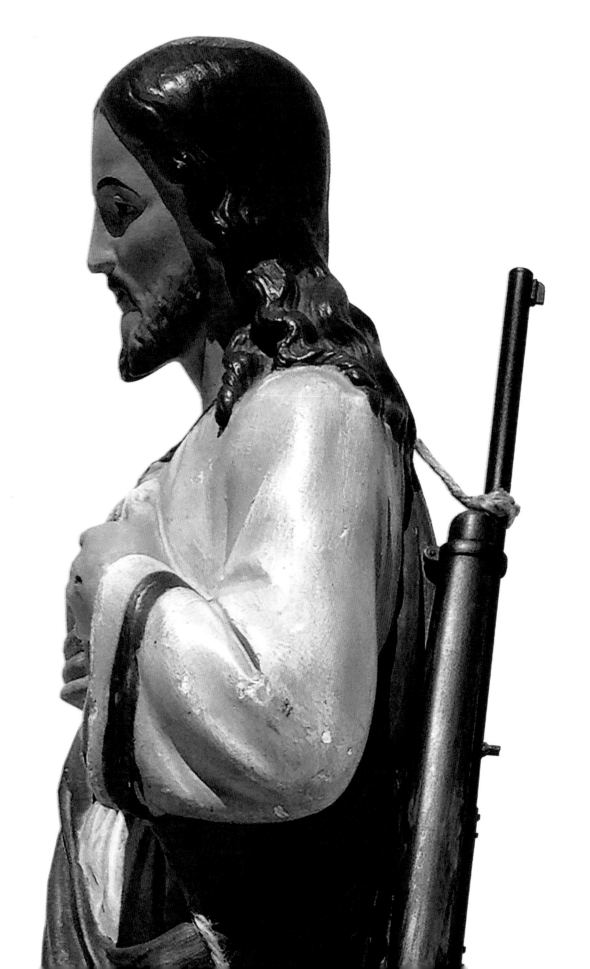

Jesus The Hunter
Plaster, wood, steel
9X24.5X4.5 inches (23X62X11cm)
Los Angeles, 2014

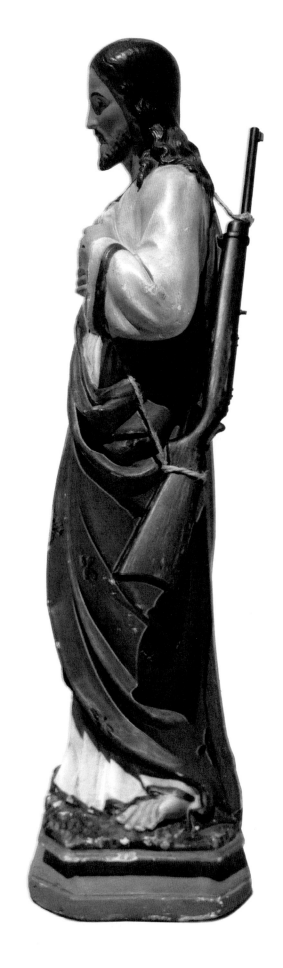

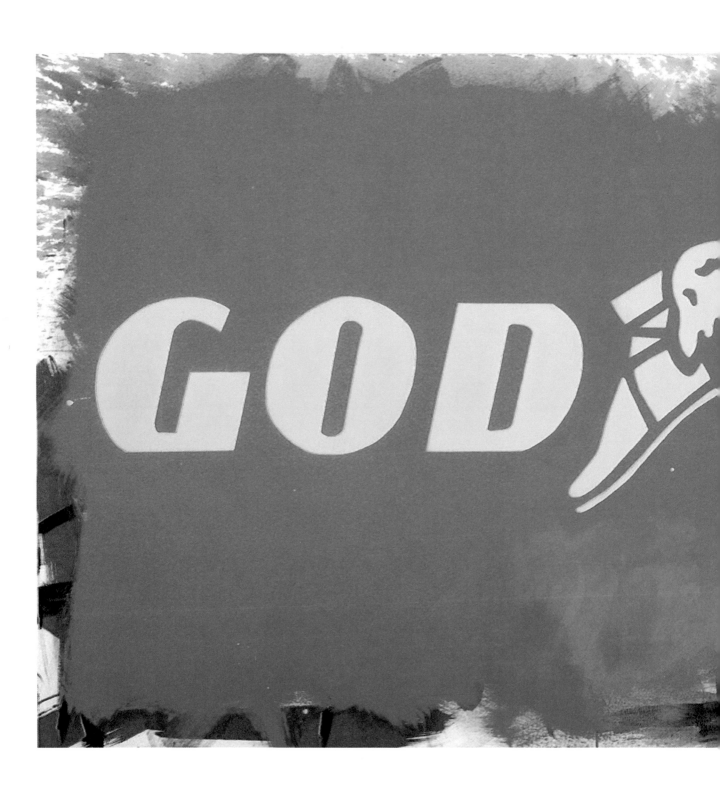

God Near, One Revolution Ahead™
Oil and acrylic on canvas
108X53 inches (274X134 cm)
Los Angeles, 2015

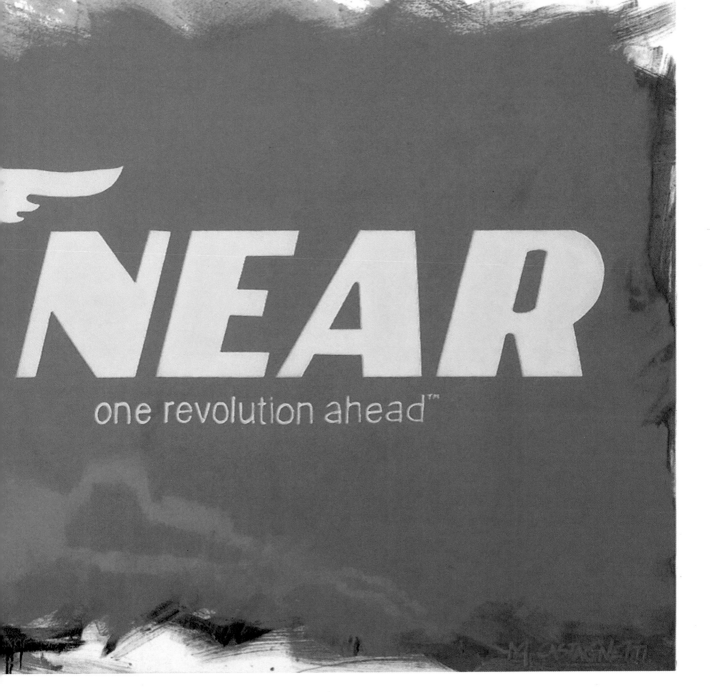

God Near, One Revolution Ahead™
Oil and acrylic on canvas
108X53 inches (122X91 cm)
Los Angeles, 2016

GOD NEAR
One Revolution Ahead™

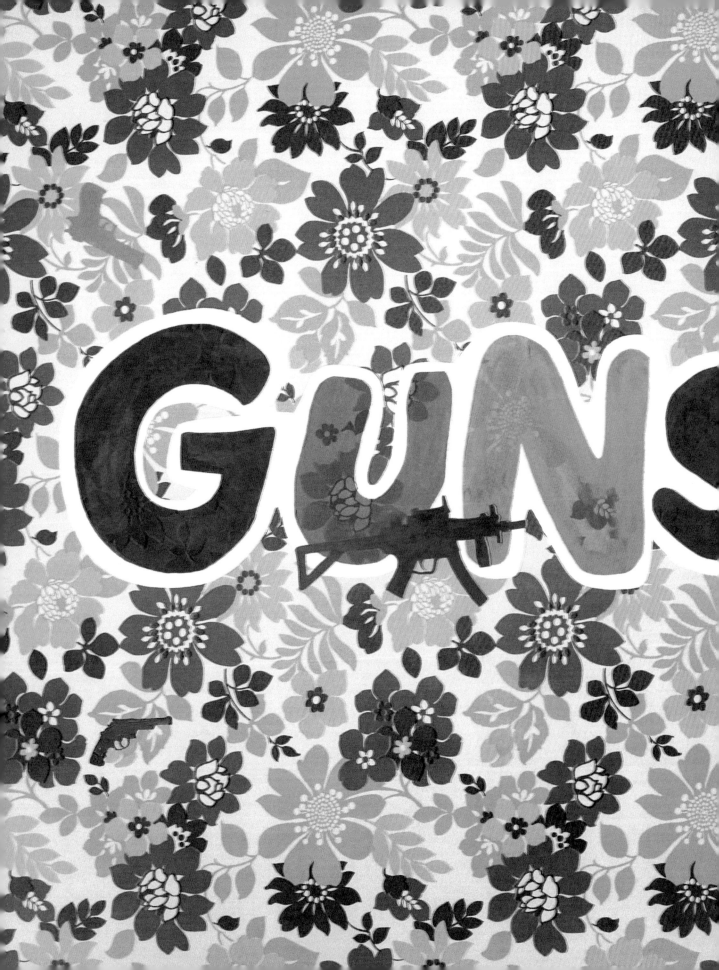

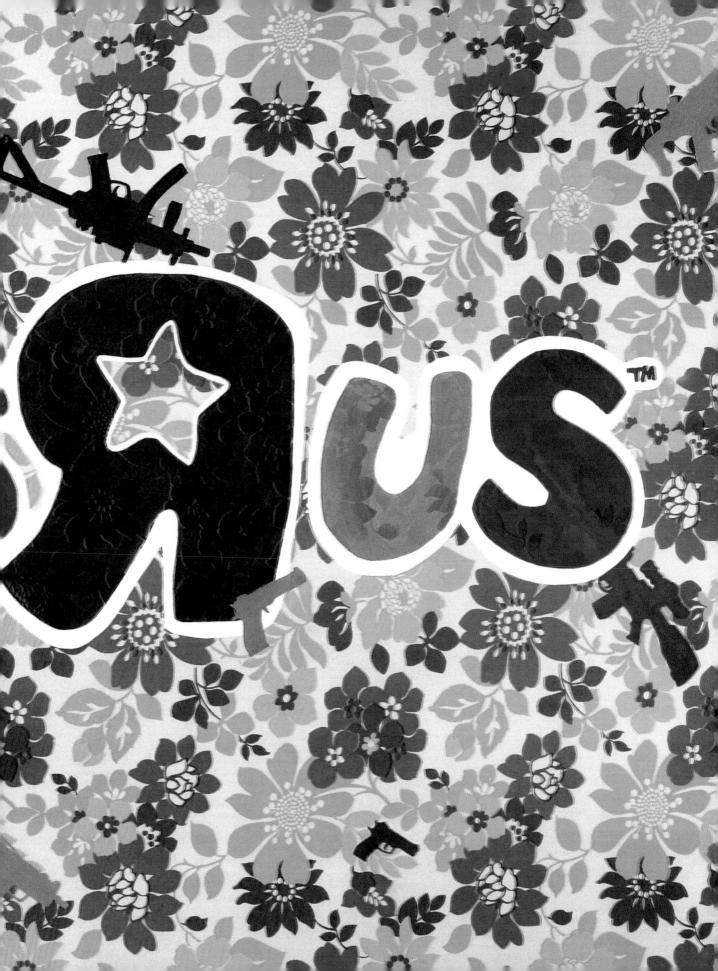

Guns R Us™
Acrylic on fabric
90X51 inches (228X129 cm)
Los Angeles, 2017

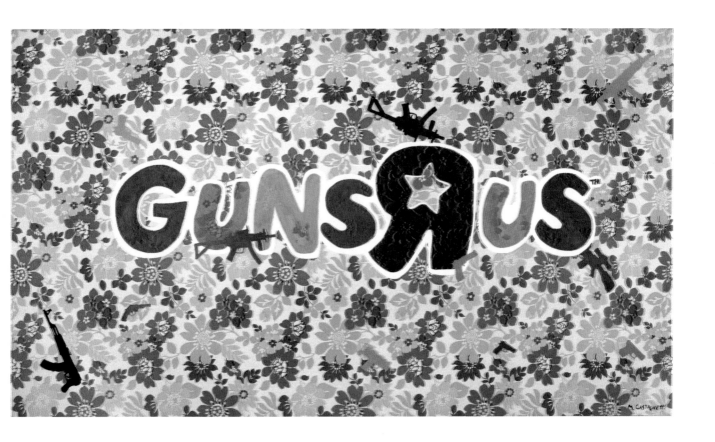

Watch Out for Children
Custom sticker on aluminum road sign
24X24 inches (61X61 cm)
Los Angeles, 2014

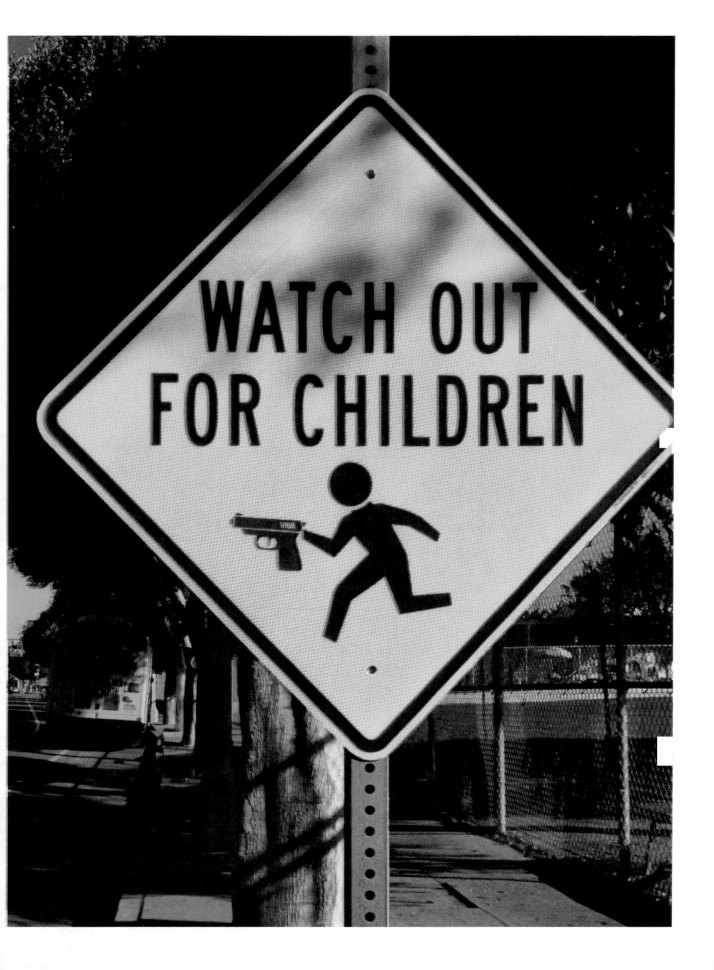

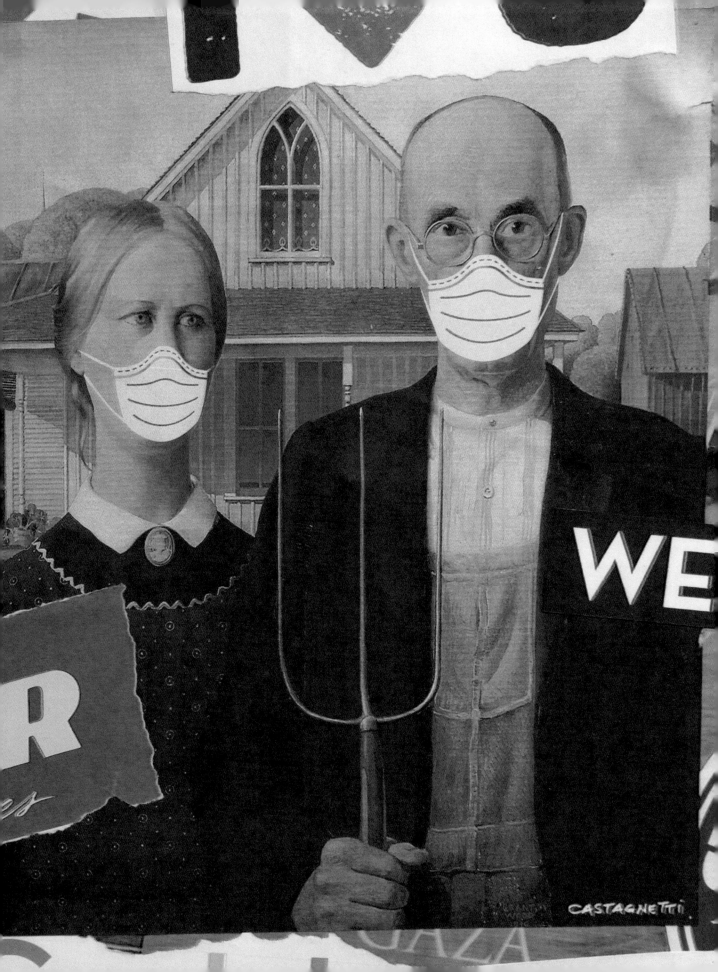

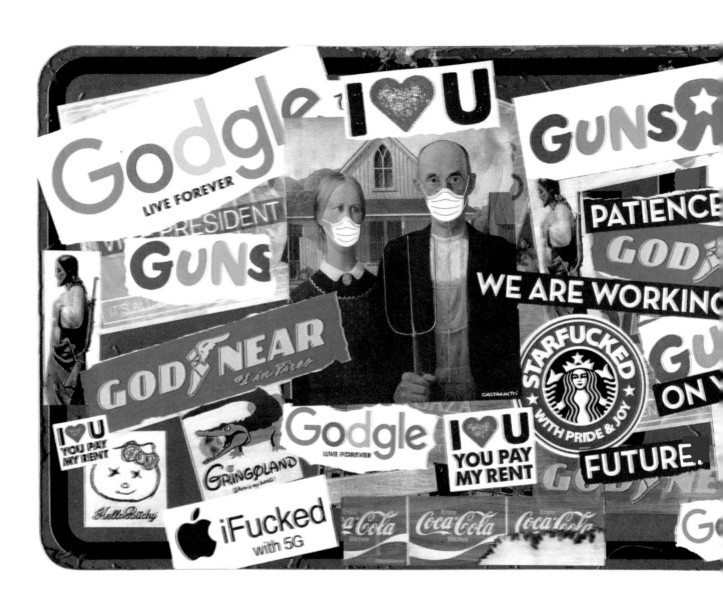

Everybody Wants to Rule the World
Custom stickers on aluminum road sign
48X18 inches (122X45.5 cm)
Los Angeles, 2020

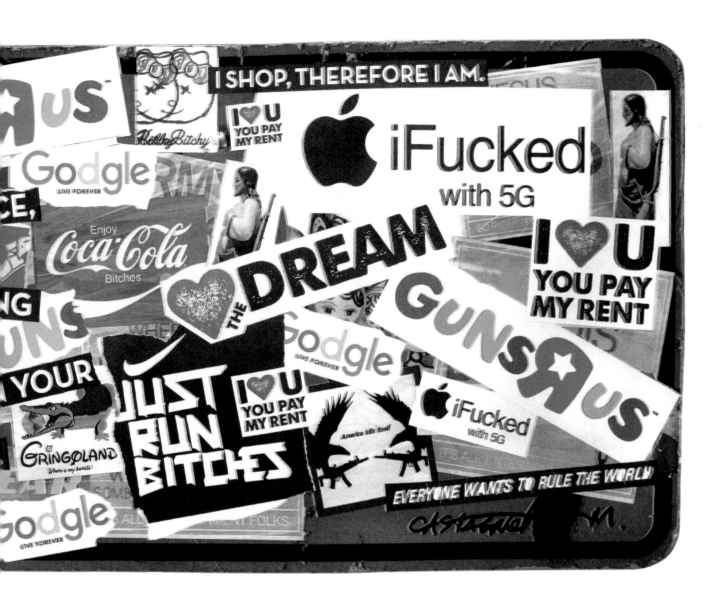

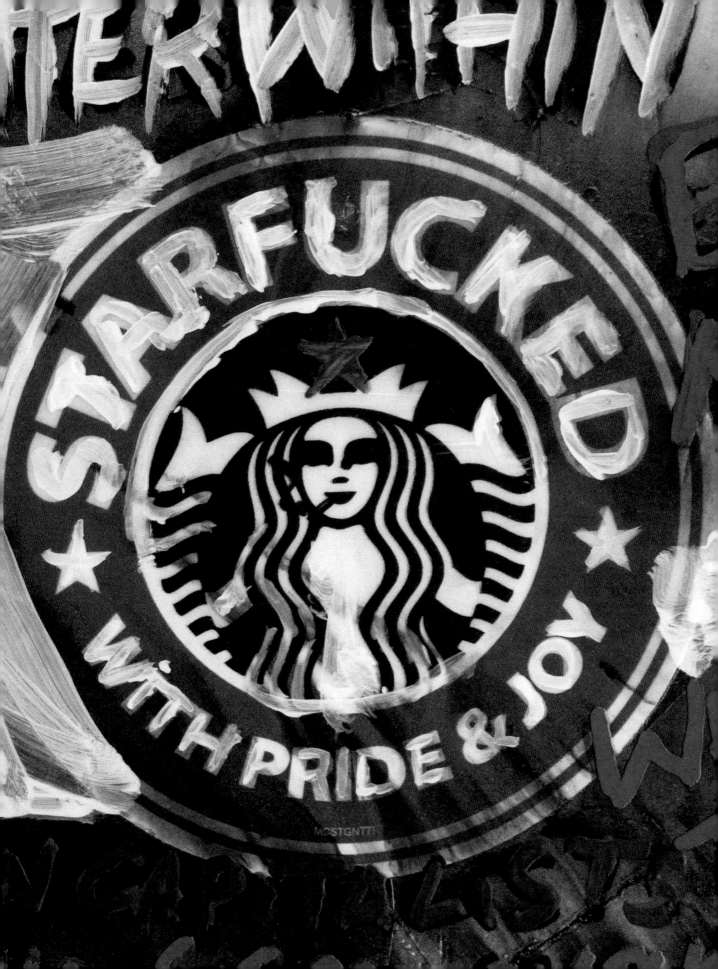

We Own The Sky
Mixed media on aluminum road sign
36X36 inches (91X91 cm)
Los Angeles, 2020

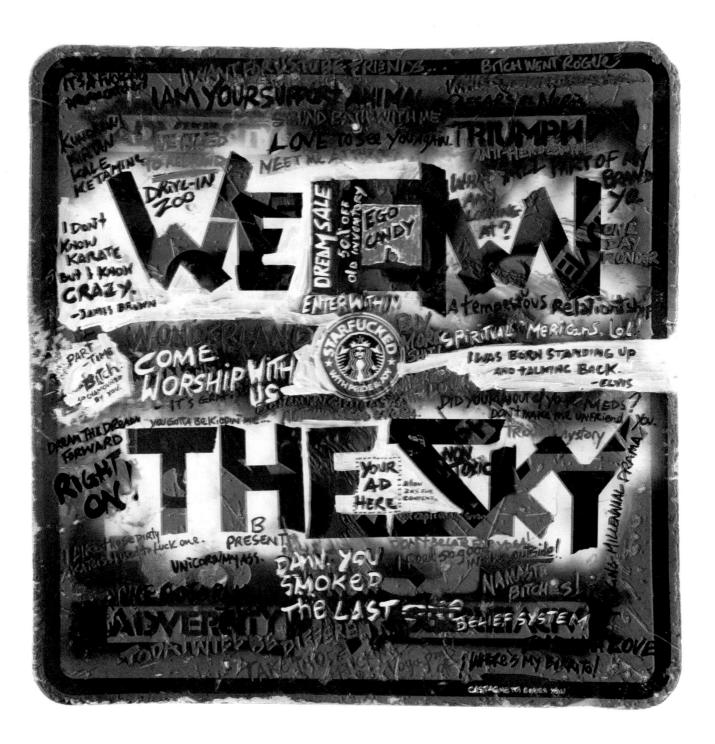

Enjoy

Coca

Bitch

Enjoy Coca Cola® Bitches™
Sharpie on canvas
42.5X30 inches (108X76 cm)
Los Angeles, 2014

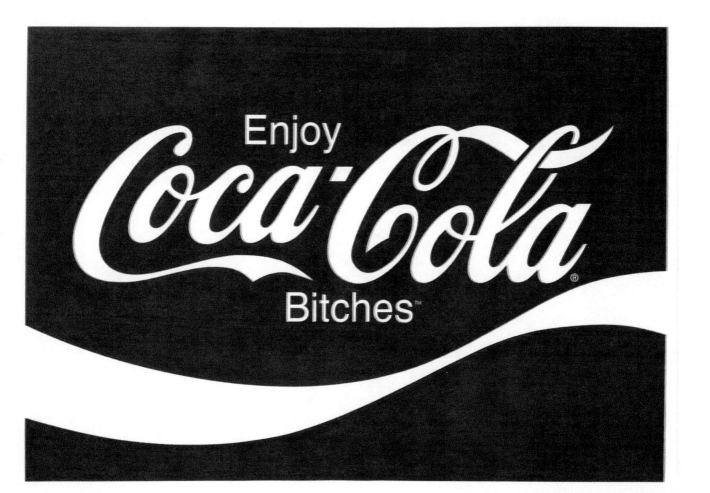

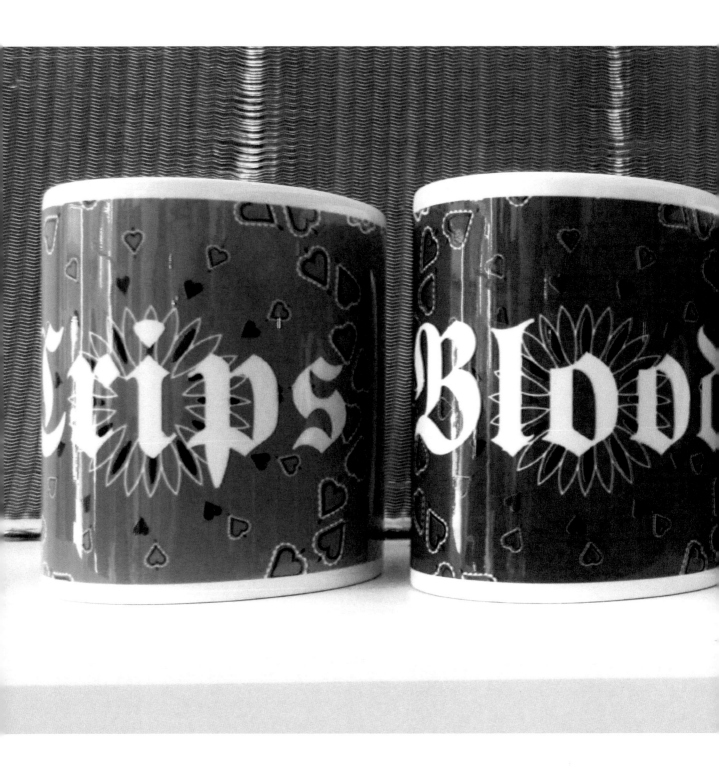

Bloods+Crips
Ink on ceramic
3.25X4 inches (8X10 cm)
Los Angeles, 2015

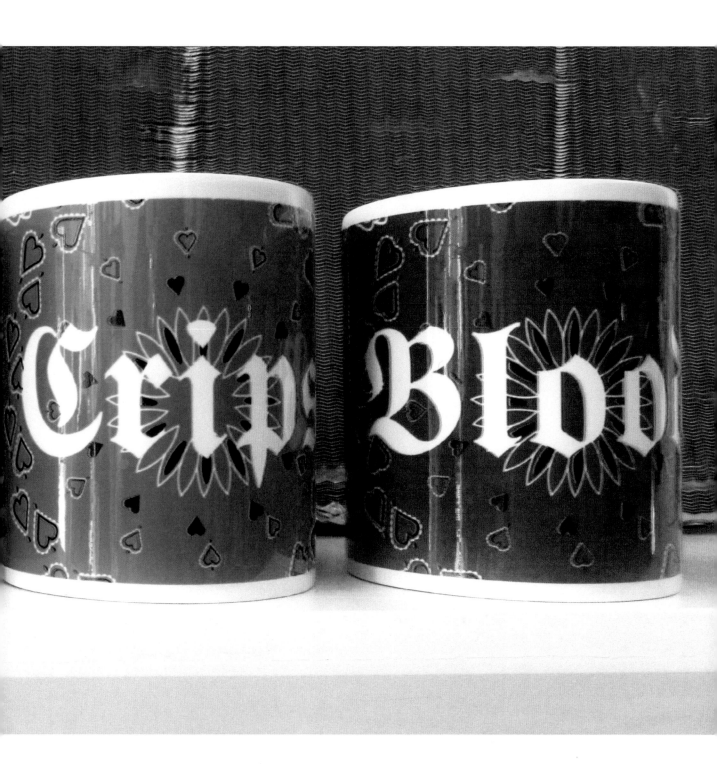

Hello Bitchy™
Sharpie and acrylic on canvas
18X24 inches (46X61 cm)
framed 26X32 inches (66X81 cm)
Los Angeles, 2015

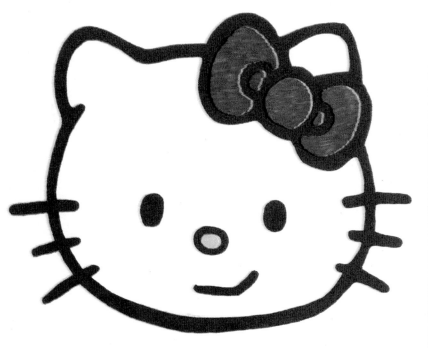

GRIN

Whe

GOLAN

is my burrito?

Gringoland™
Acrylic on Canvas
48X48 inches (122X122 cm)
Los Angeles, 2018

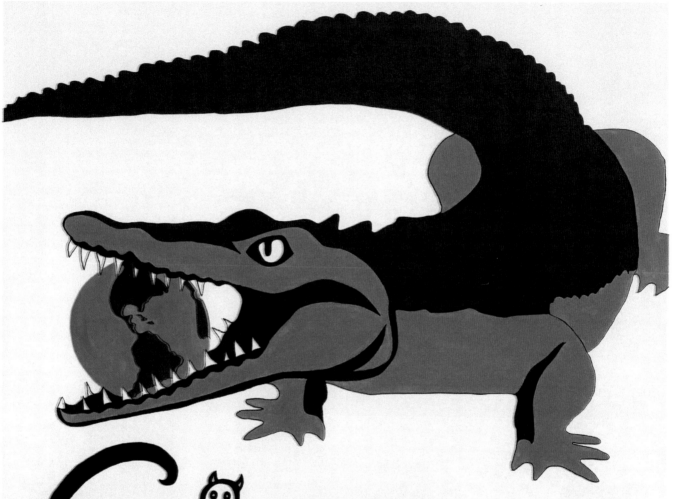

GRINGOLAND™

Where is my burrito?

Ego
Acrylic and operating zipper on canvas
31X45 inches (79X114 cm)
Los Angeles, 2007

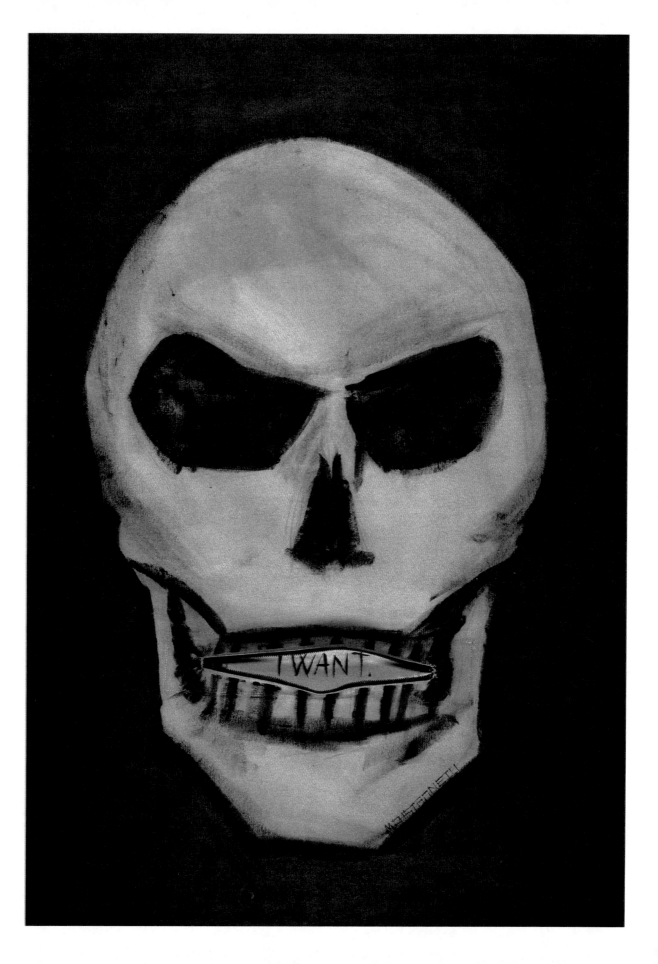

la guerra
é sempre
di moda

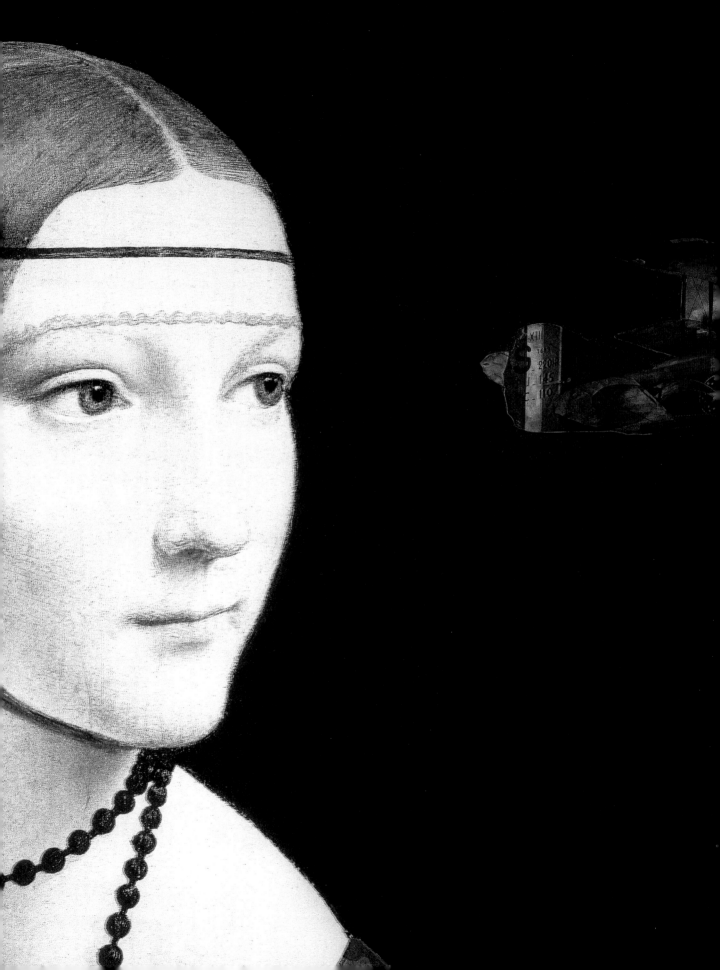

La guerra é sempre di moda
trans. "War is always in fashion"
Acrylic and mixed media on canvas
24X30 inches (61X76 cm)
Los Angeles, 2007

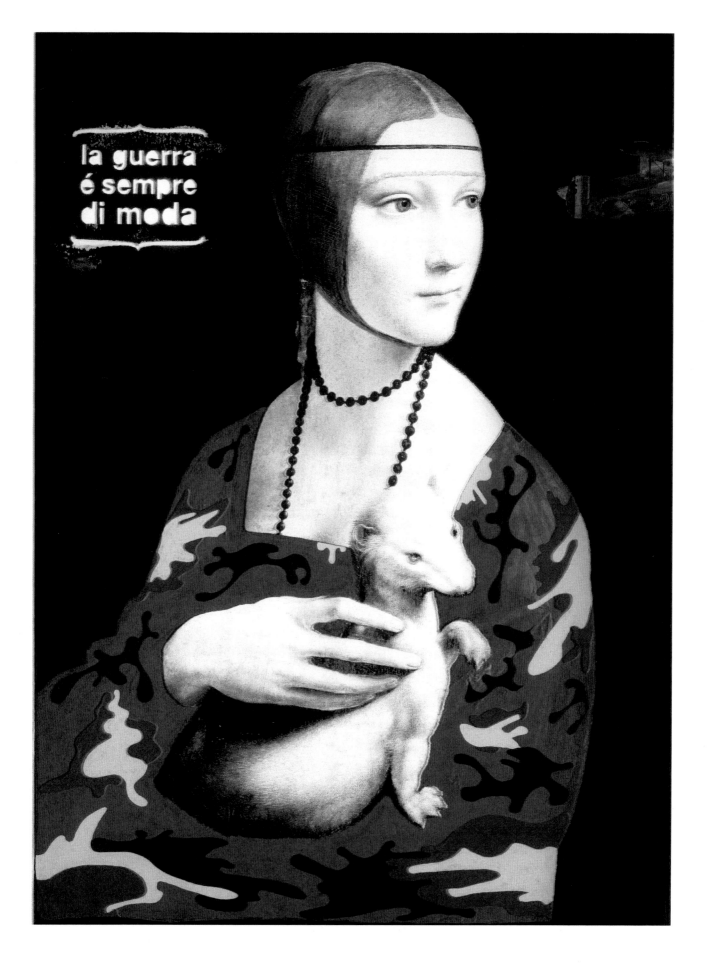

Traditional processing method:
Coarse bronze drawings

Spaghetti Western
(DeCecco/Claudia Cardinale)
Custom print on boxed canvas
22.5x78x6 inches (57X198X10 cm)
Los Angeles, 2016

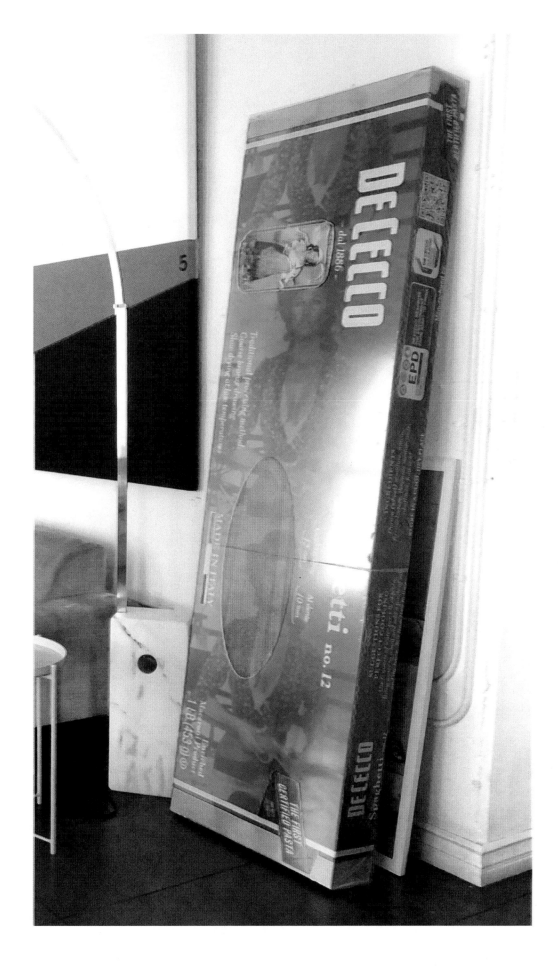

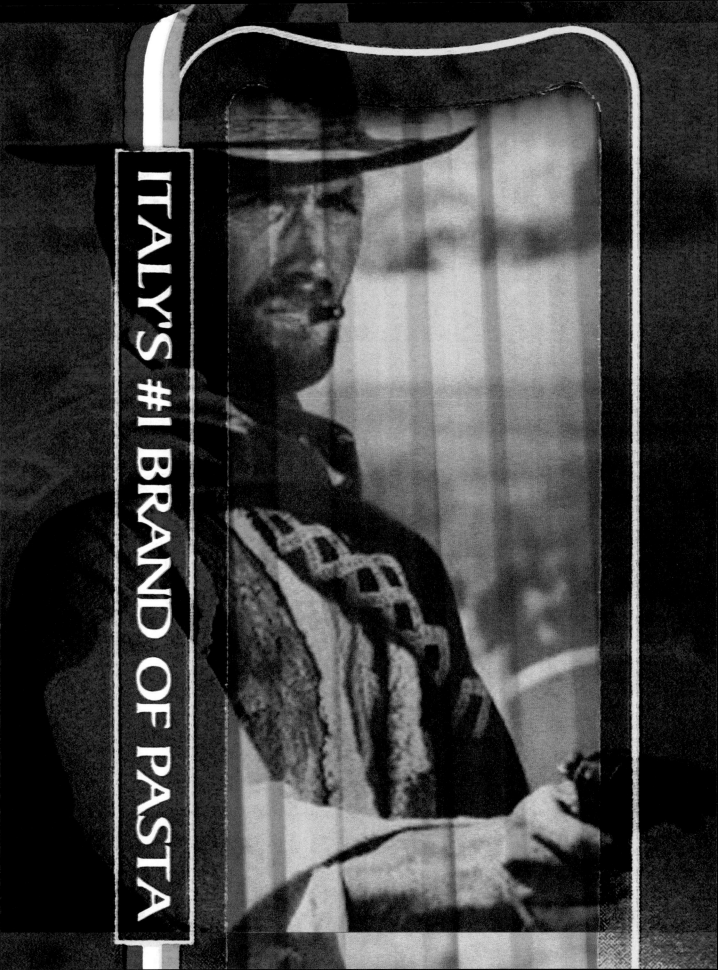

ITALY'S #1 BRAND OF PASTA

Spaghetti Western
(Barilla/Clint Eastwood)
Custom print on boxed canvas
38X115X4.5 inches (96X292X11 cm)
Los Angeles, 2010

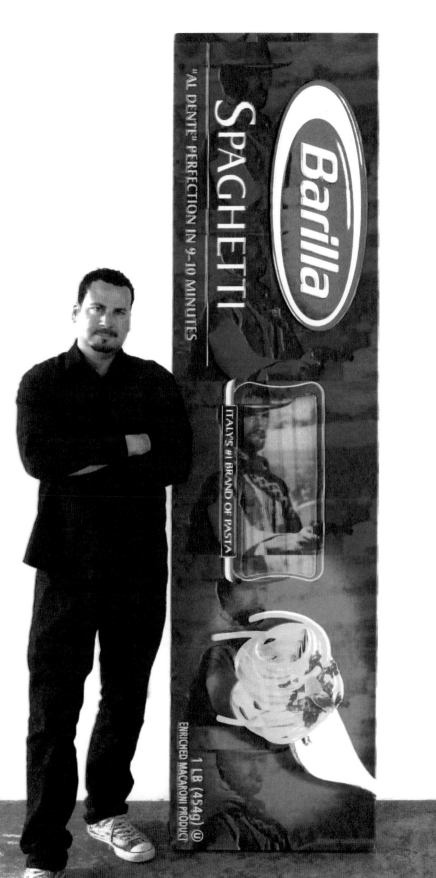

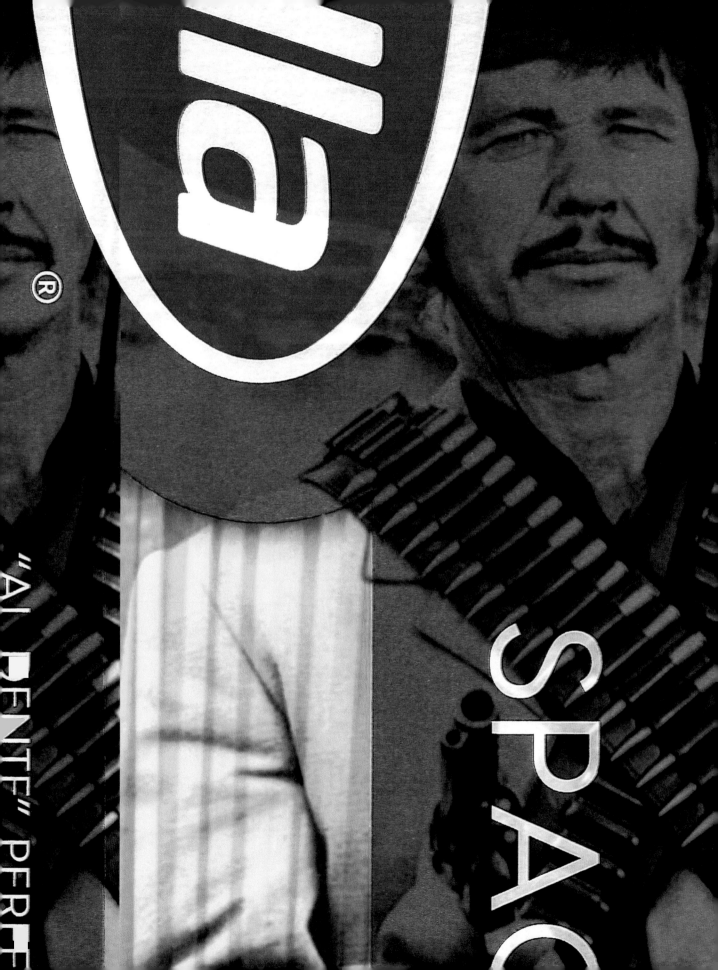

Spaghetti Western
(Barilla/Charles Bronson)
Custom print on boxed canvas
24X96X6 inches (61X244X15 cm)
Los Angeles, 2017

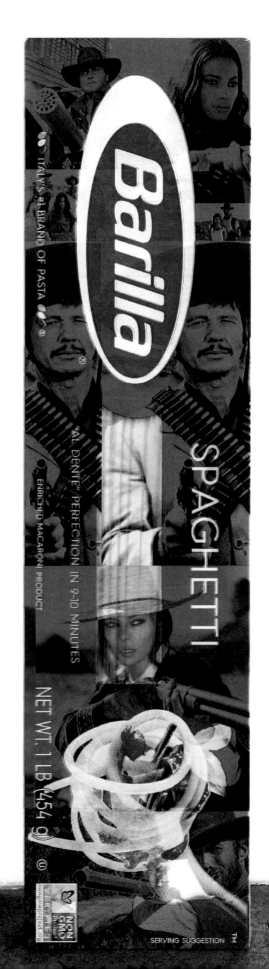

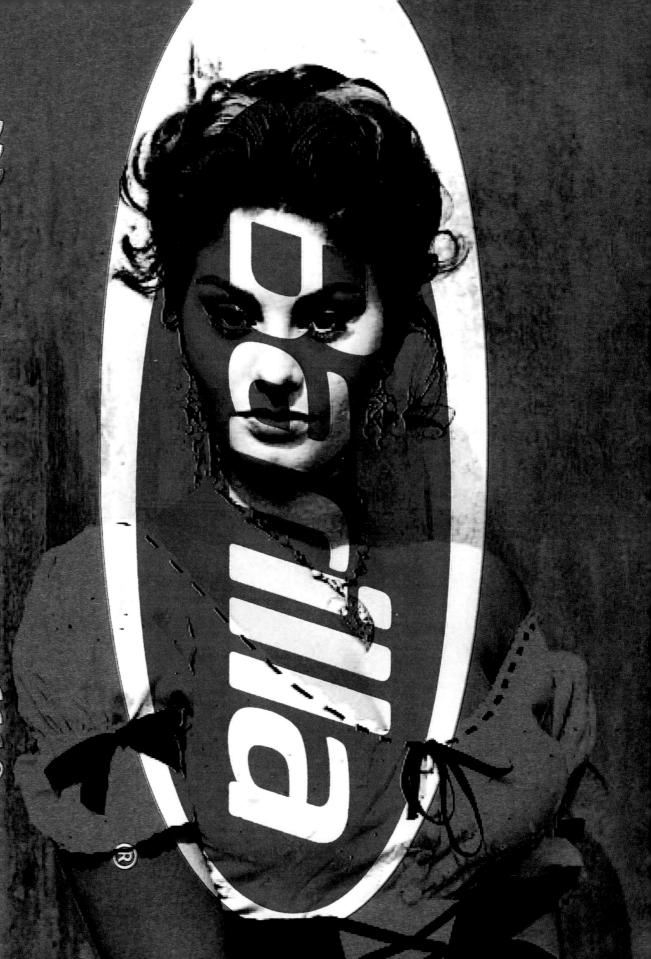

Spaghetti Western
(Barilla/Sofia Loren)
Custom print on boxed canvas
20.5X76X6 inches (52X193X15 cm)
Los Angeles, 2018

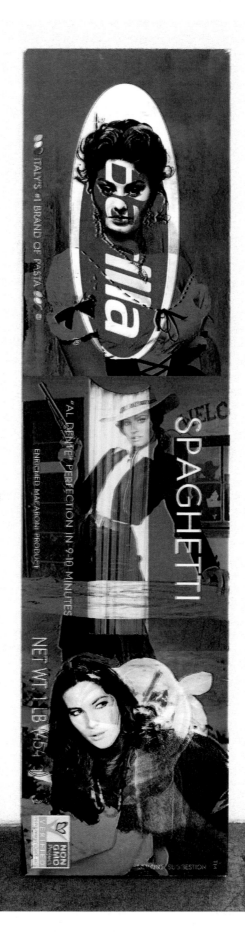

ITALY'S #1

Spaghetti Western
(Barilla/Claudia Cardinale)
Custom print on boxed canvas
24X94X10 inches (61X240X26 cm)
Bologna, Italy 2019

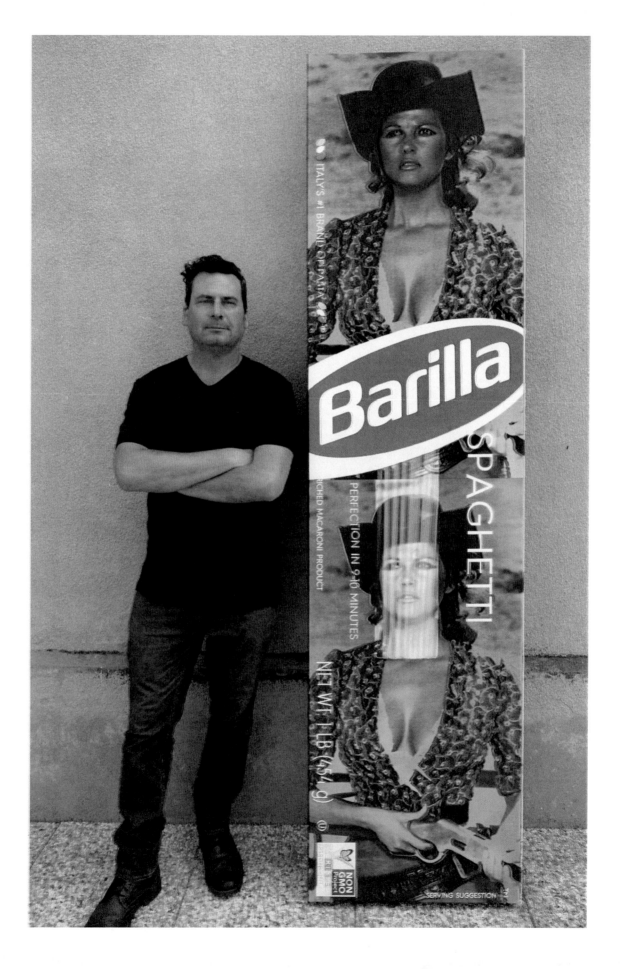

True Finish
Archival Print
30X40 inches (76X101 cm)
Los Angeles, 2014

Infinite Presence
Fabric on wood
48 inches round (123 cm round)
Los Angeles, 2014

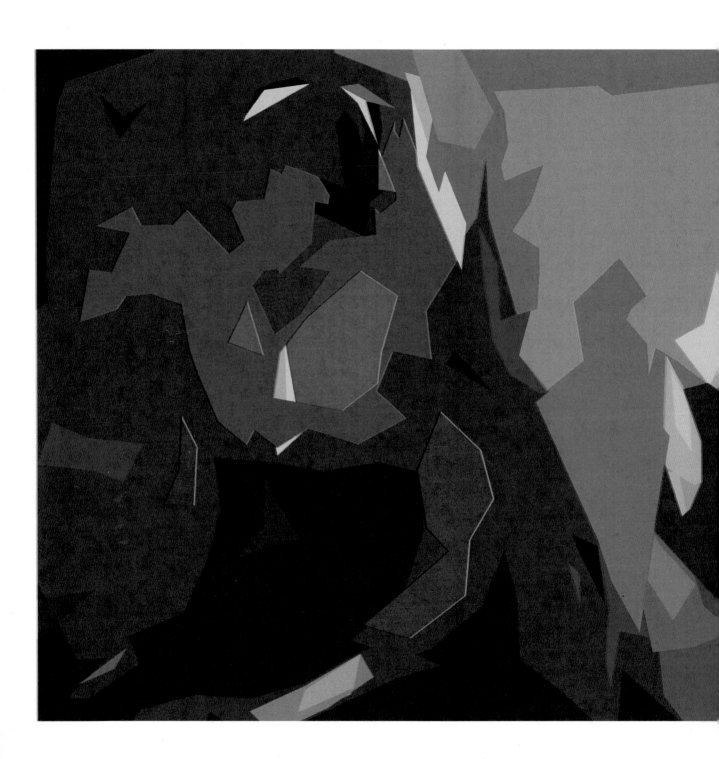

3 Women
Custom print on canvas
108X53 inches (274X134 cm)
Los Angeles, 2007

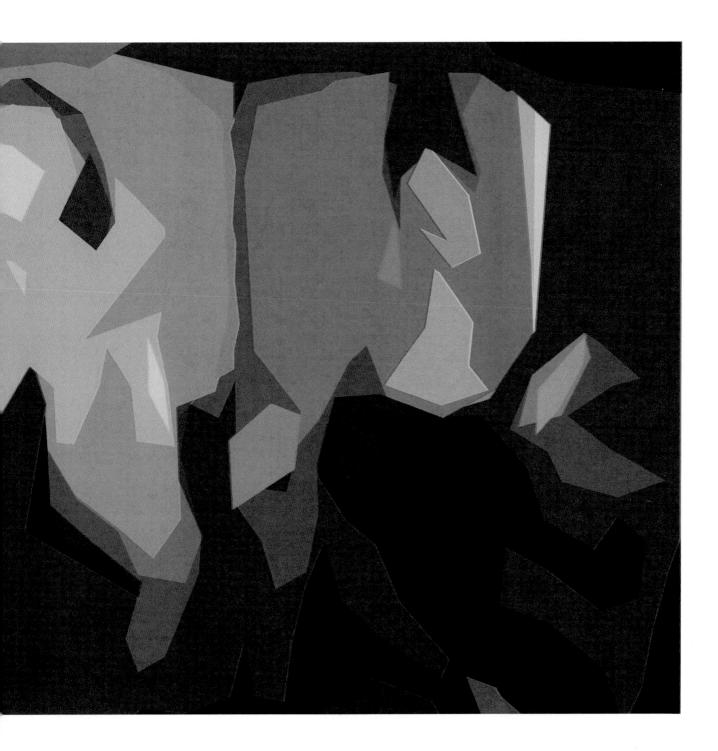

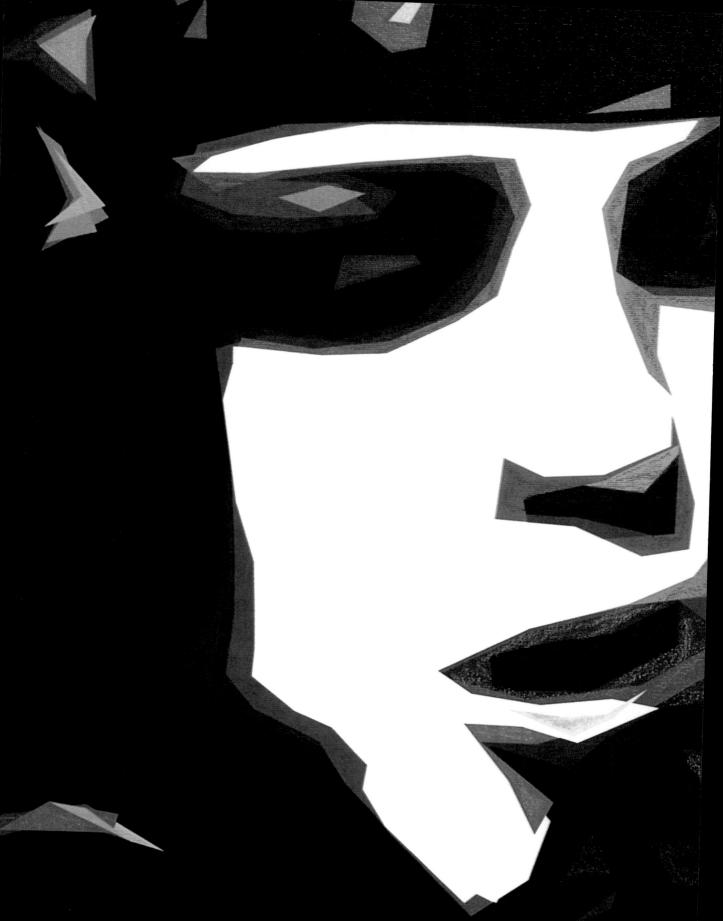

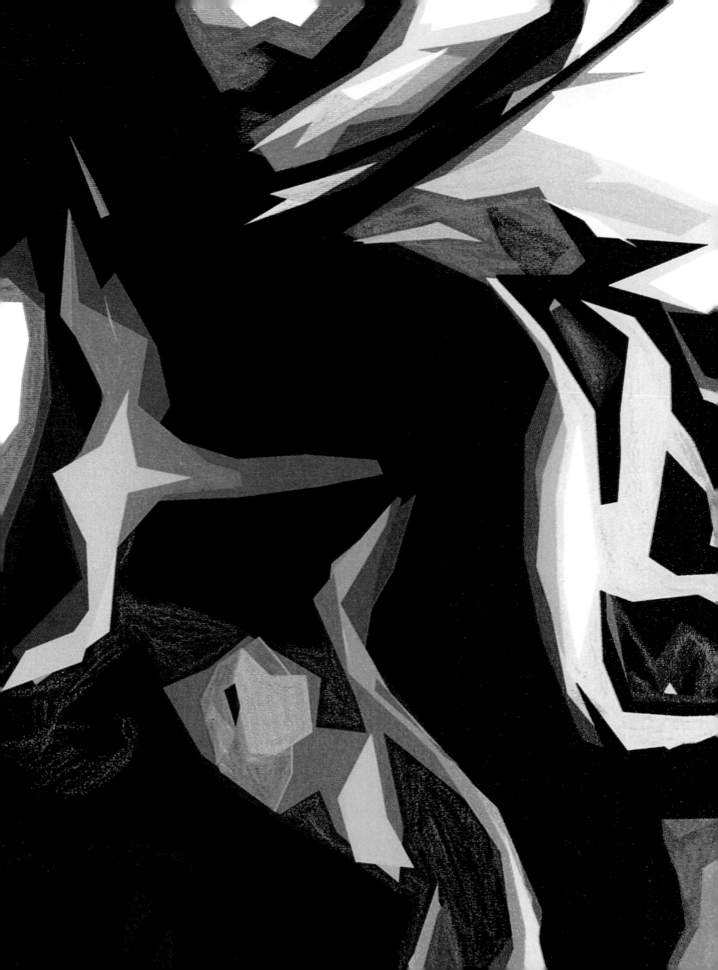

The Soul
Oil pastels and ink on canvas
30X40 inches (76X101 cm)
Los Angeles, 2017

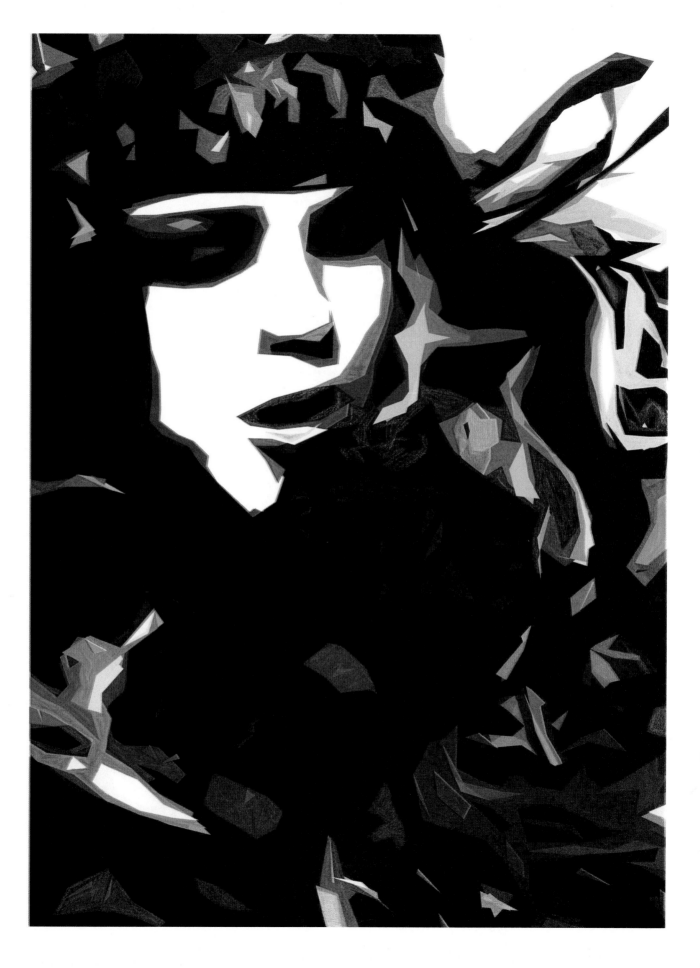

World Reverse
Watercolor on paper
60X36 inches (153X91 cm)
Los Angeles, 2017

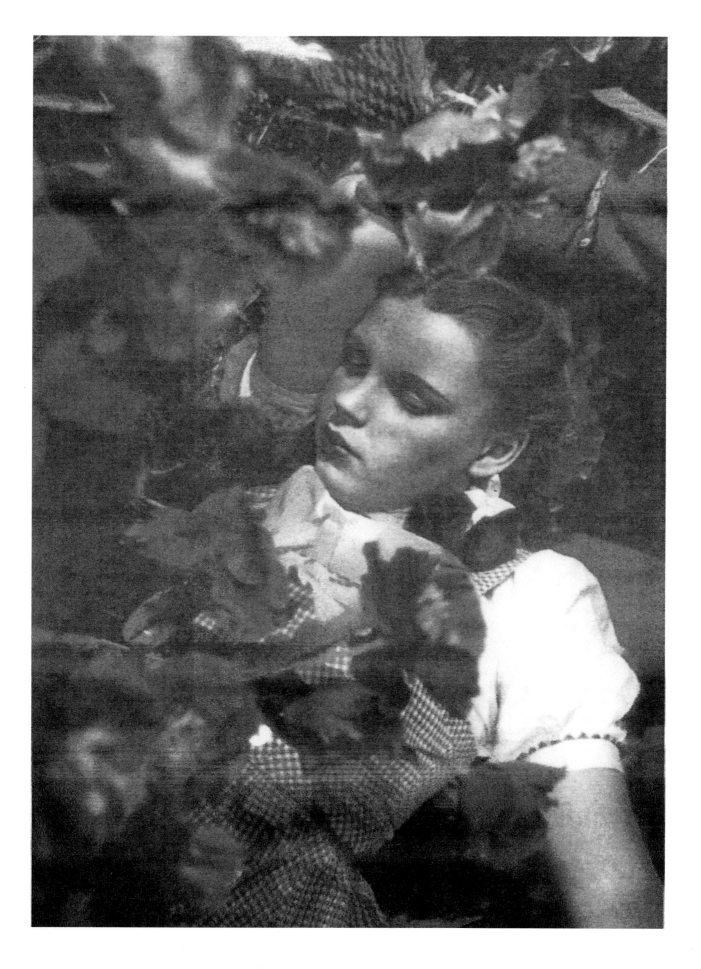

American Dream
Triptych on paper
30X41 inches each (76X104 cm)
Los Angeles, 2021

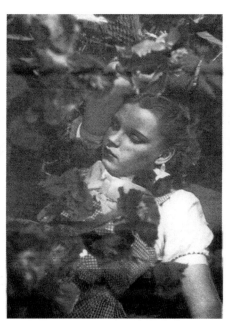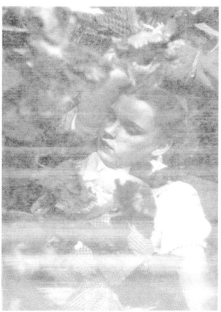

Godgle
Logo with tag line
Variable sizes
Los Angeles, 2019

The irreverent work of the Los Angeles-based Italian artist
Michele Castagnetti has appeared in numerous exhibitions
by notable curators and critics such as Peter Frank,
Mat Gleason and David Pagel of the Los Angeles Times.

Made in the USA
Middletown, DE
24 April 2022